Raffler's Cats

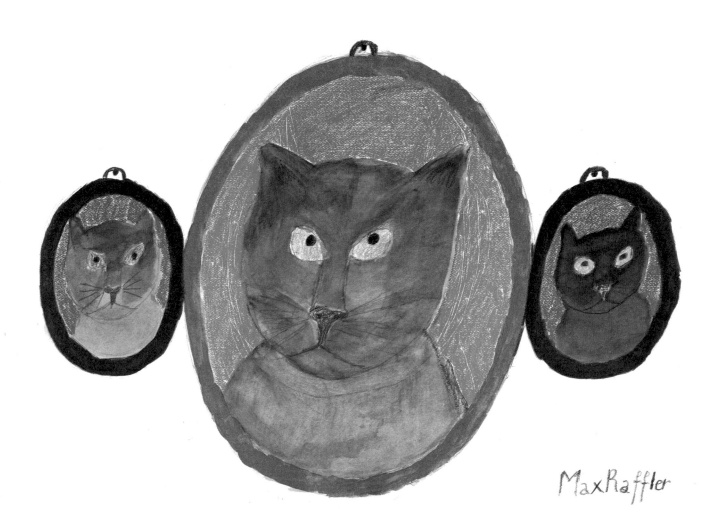

MaxRaffler

Raffler's Cats

Max Raffler

Random House · New York

First American Edition.
Copyright © 1982 by Carl Hanser Verlag

Library of Congress Cataloging in Publication Data
Raffler, Max, 1902–
Raffler's cats.
Translation of: Max Raffler's Katzen.
1. Raffler, Max, 1902– . 2. Primitivism in art.
3. Cats in art. I. Title.
ND588.R322A4 1982 759.3 82-18079
ISBN 0-394-71306-0

Manufactured in the United States of America

24689753

Max Raffler's Cat Paradise

With my great strength and arms outstretched,
I have created the earth, mankind and all
the animals. As to what I do with them,
that's my business.

—GOD

When Adam and Eve were expelled from Paradise, with God's far-reaching and, in light of our experience, somewhat exaggerated curse upon their heads, they were obliged to leave behind not only pristine nature—perpetual sunshine; efflorescent meadows; a splendid apple tree bearing, in addition to delectable fruit, an unfriendly serpent. So far, so good. But ever since that memorable day, mankind has been wondering whether a yellow-red apple was the sole cause of our wretched fate. Or wouldn't God have continued to test Adam and Eve even if they had complied with His first prohibition? Something is wrong with this scary tale of the Garden of Eden; anyone who has pondered the foregoing question while trying with childlike passion to imagine his very own paradise senses as much. But who can tell us what? Who, except God? And understandably enough (judging from His ways), God does not allow Himself to deal with such questions.

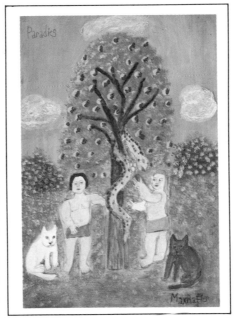

This problem that has haunted us since the dawn of time has been solved by the painter Max Raffler. When we look closely at his picture of Paradise—that singular celebration of growth and prosperity—we appreciate with rare lucidity what those two unhappy human beings did to themselves and their progeny. Sitting next to Adam and Eve are two cats, one white, the other brown, who look out on posterity with heartbreaking, aggrieved expressions, erasing any doubt as to their profound knowledge of the impending catastrophe. They were witnesses to God's inscrutable decree. They knew how the universal drama would end. As Adam and Eve acted their roles in blissful ignorance, our fate hung on more than an apple. From that day onward, cats—mimics par excellence—have been the true bearers of the secrets of the universe, secrets we have since been asking them about. The sad, affecting faces of the two cats in the picture eloquently express despair over the fact that Adam and Eve arrived at so momentous a decision not *with* but *without* them.

Therefore, both cats sit, privy to the mystery of the Fall, unhappy amid happiness, bewildered, speechless. Now Paradise belongs only to them; but all along they knew what the outcome would be. Their descendants all have that same look about them, and every hand that strokes one of these creatures tries unwittingly to rub out some guilt—in vain, as anyone who has had to cope with the complicated soul of cats knows. For even if you coax them with the sweetest endearments, they will still refuse to take the final step toward reconciliation with mankind.

Poets have always been closest to the secrets of cats. In unending variations and repetitions they have sung the praises of these animals, have evoked and compared every whisker, every movement, cat fur, cat eyes, hoping to get to the heart of the mystery of feline existence, so intimately related to ours. But even the greatest among them, from Baudelaire to T. S. Eliot, who have most keenly described the relationship between cat and man (too often obsequiously forgiving the animal everything and man nothing), have failed to achieve the insight shown by

Raffler's simple work. Painters have fared even worse. If you roam the museums of Europe in search of cats, you will find them only rarely. Ox and ass, snake and mouse, pig, horse, bird and elephant, in every imaginable pose, appear throughout the centuries in every country. Cats have had only scant access to this painterly menagerie. Here, in Holland, one sits under a table grimly observing a corrupt Bacchanalia; there, another, horrified by a party of marauding French ruffians, leaps out of the canvas. On no other occasion do we see cats in the middle of things, assuming their habitual place beside some human being, as a challenge, a caveat, the living symbol of the incompatibility of human and animal conceptions of happiness.

At the end of the long and laborious effort to seal the breach between cat and man stands Max Raffler, the farmer-painter of Ammersee. In his inimitable way he has raised the issue afresh and, as a result, has been empowered by the Imperial Council of Cats to portray its populace. Understand: not this cat or that cat but cats as such: their hierarchy and behavior; their customs and manners; their nature—yes, warm as fur; their peripatetic culture; their most intimate dreams and visions of the good life. In short, their essence. Max Raffler is therefore the most reliable historian of cats, their most accurate chronicler. And even if, as his clients' loyal advocate, he cannot surrender to human importunity and, for the benefit of mankind, reconcile feline and human conceptions of the good life, he has at least portrayed the division, thereby giving us the opportunity to regard cats with more than our usual respect, dignity and love. For cats (as we have learned from Max Raffler) remained in Paradise, after our own entirely justified expulsion. So if ever again we should yearn to go back—even if everything we know argues against it—we would do well to assure ourselves *in advance* that cats would intercede on our behalf. Then they would no longer need to look at us as dejectedly as they do in Raffler's painting of Paradise.

—Michael Krüger

(Translated from the German by Erroll McDonald)

Raffler's Cats

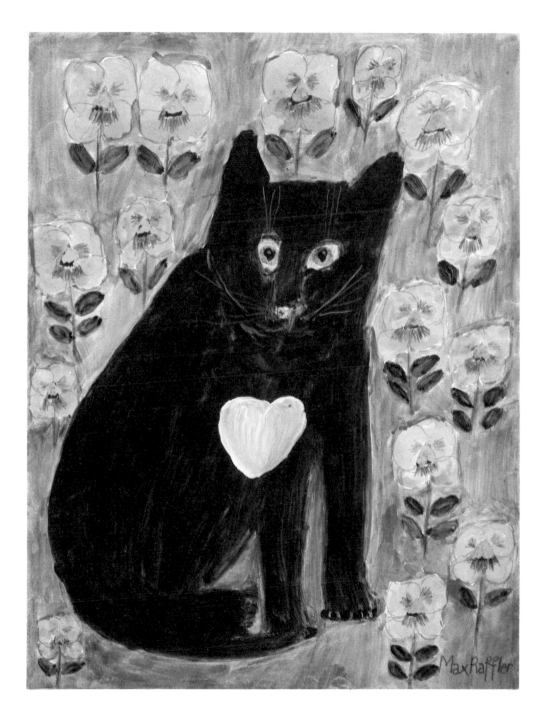

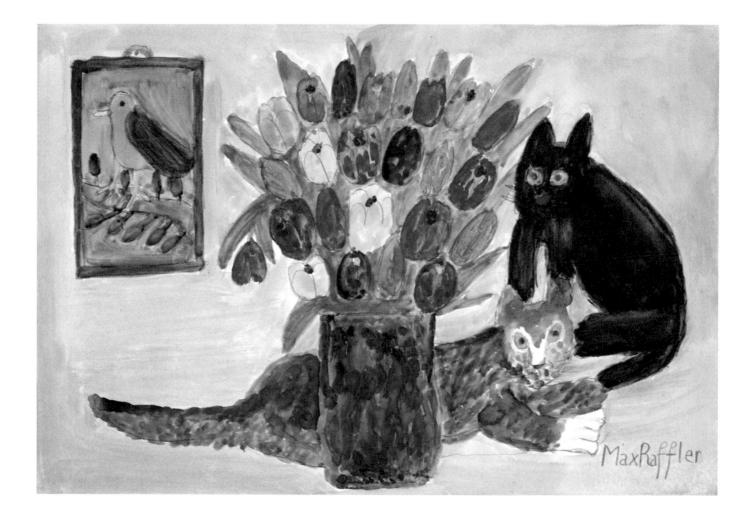

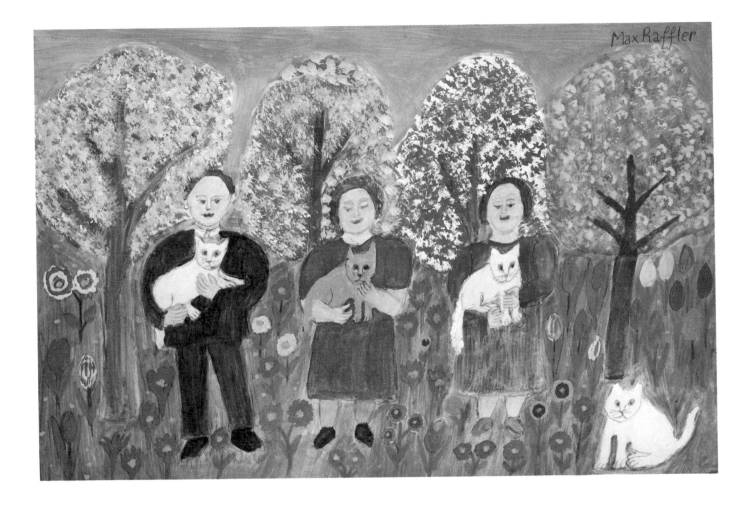

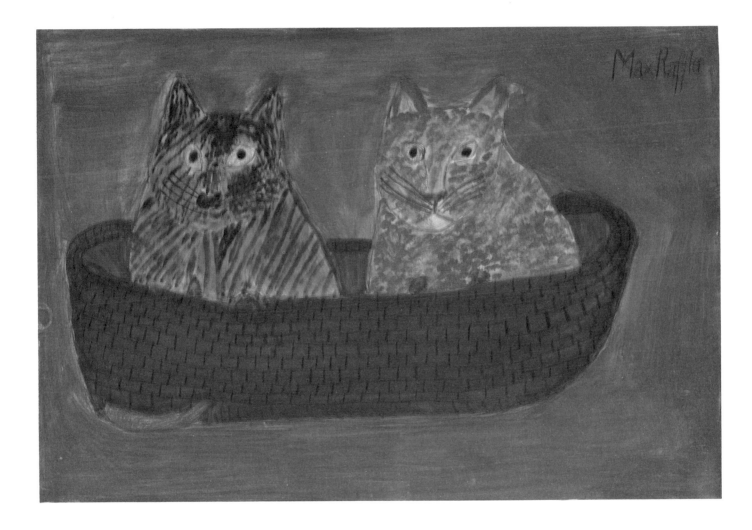

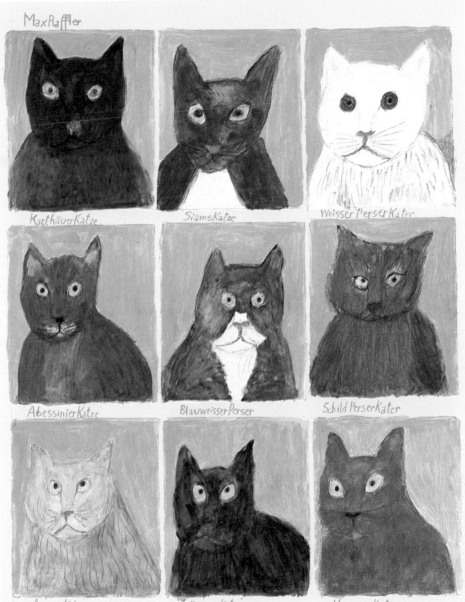

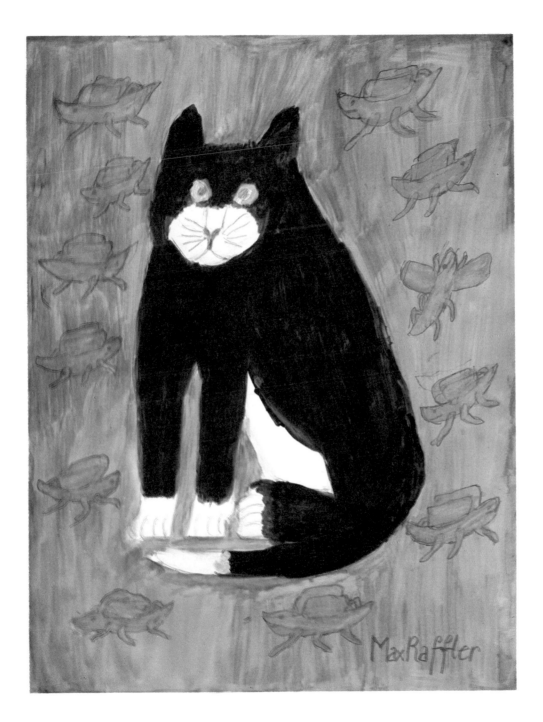

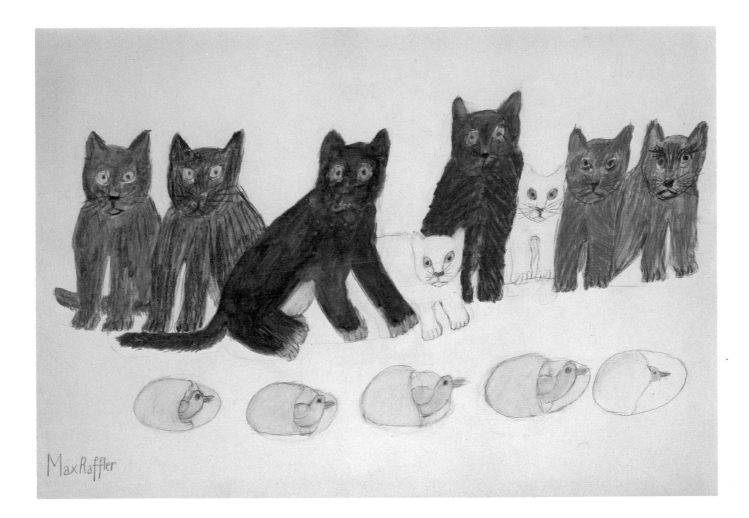

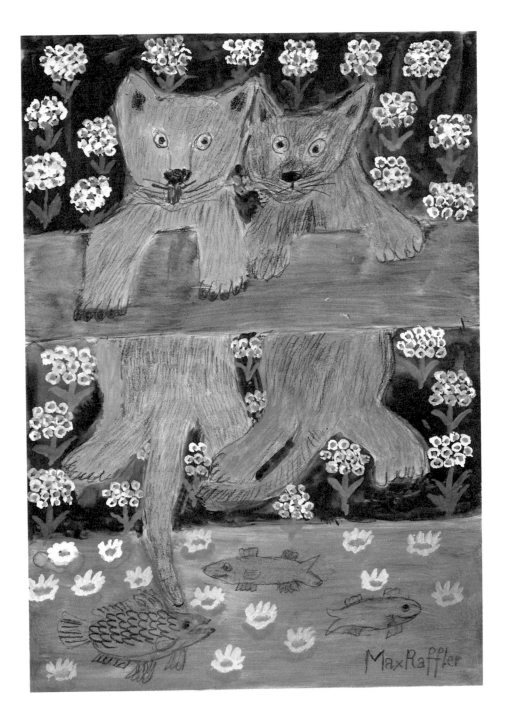

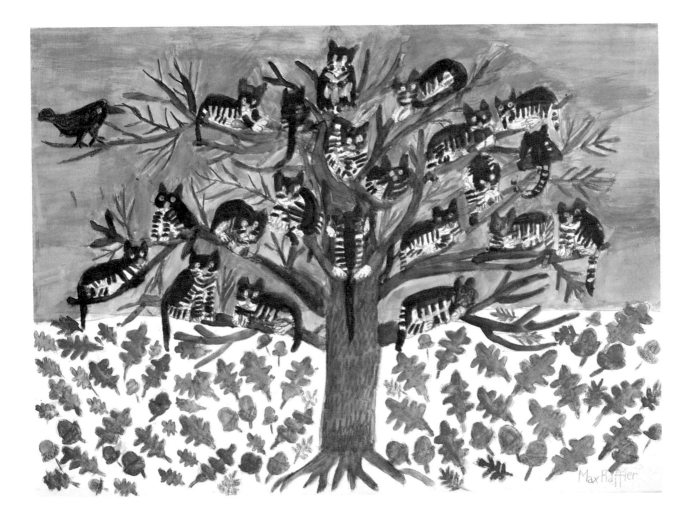

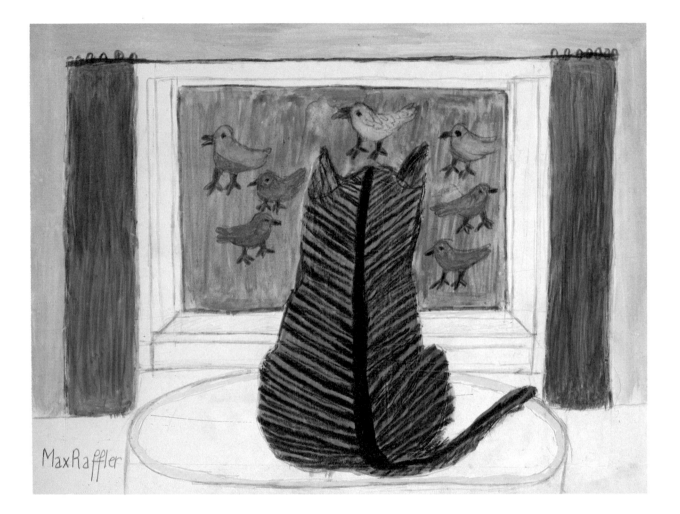

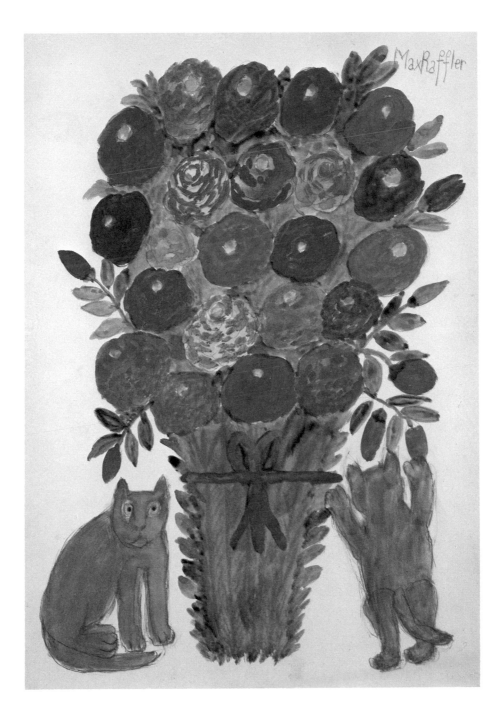

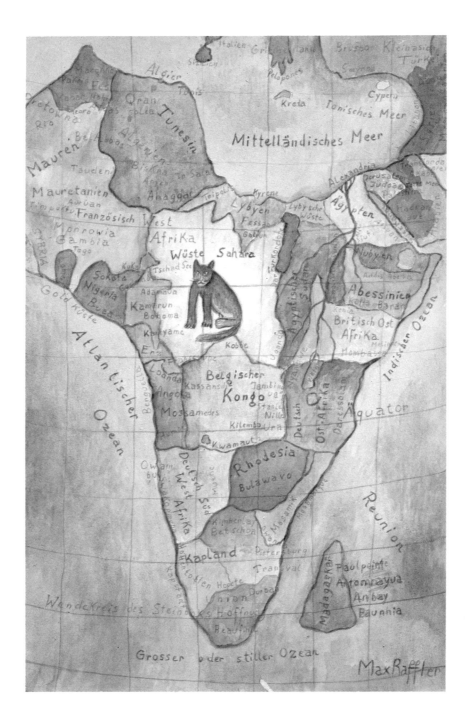

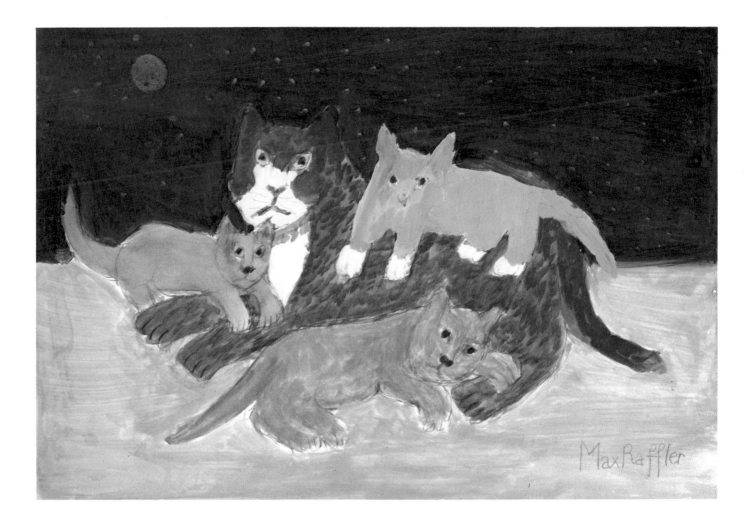

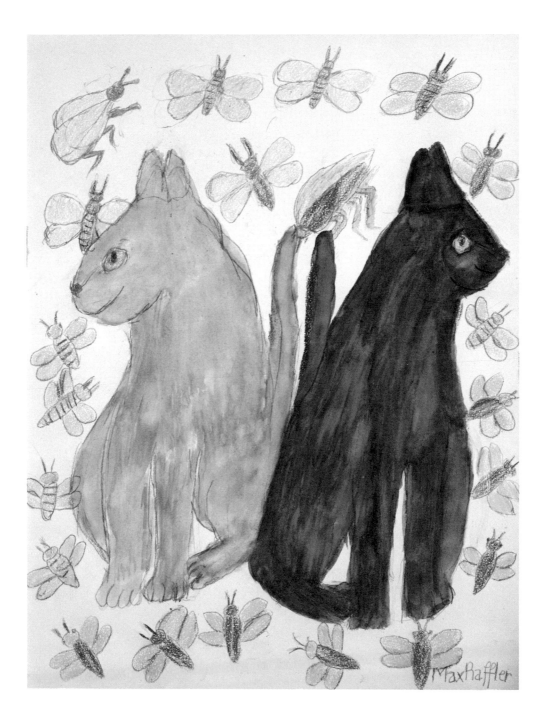

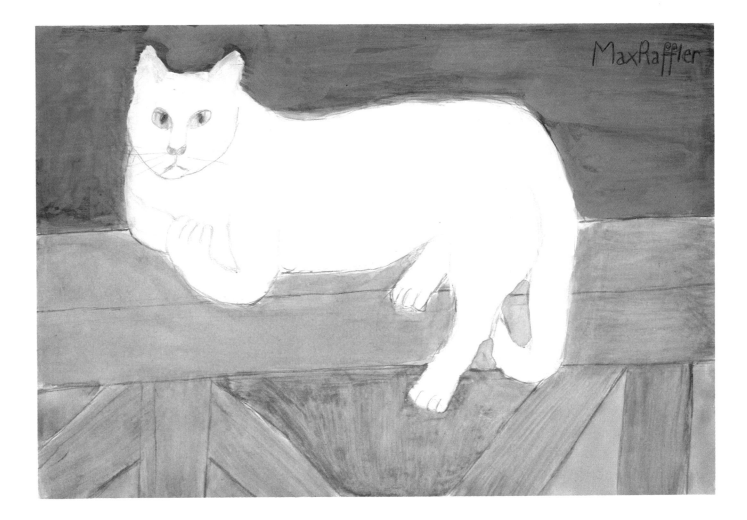

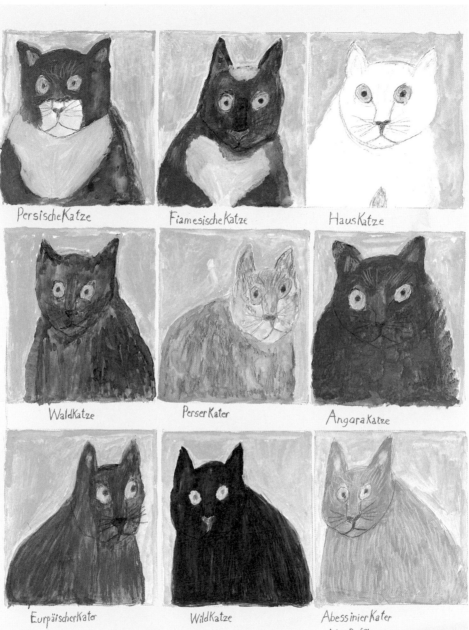

Persische Katze Fiamesische Katze HausKatze

WaldKatze PerserKater AngaraKatze

Eurpäischer Kater WildKatze Abessinier Kater
 Max Raffler

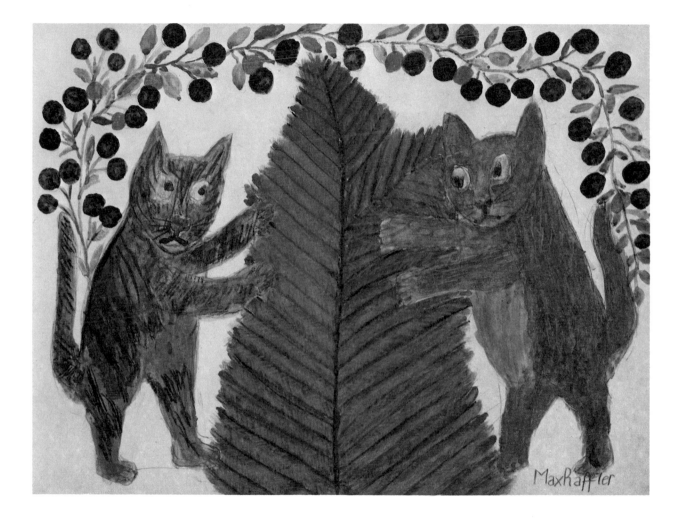

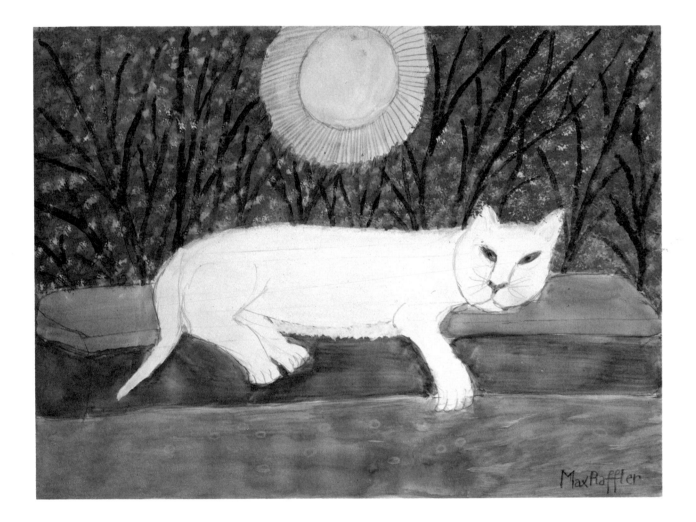

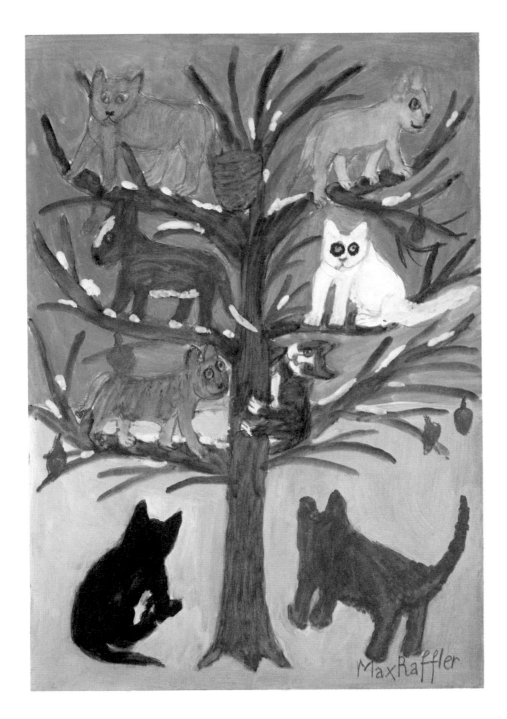

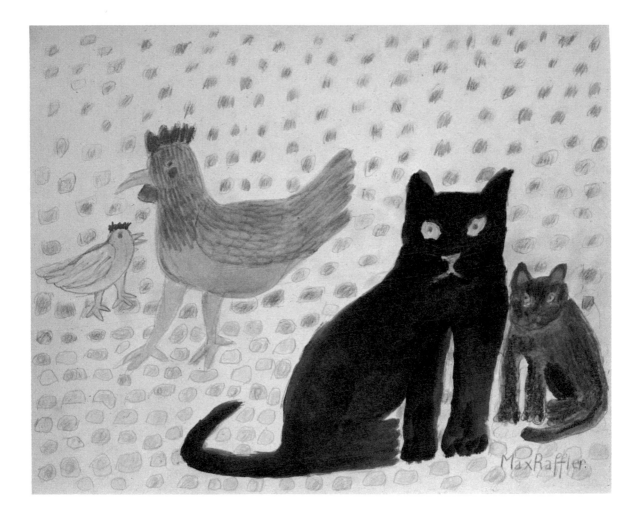

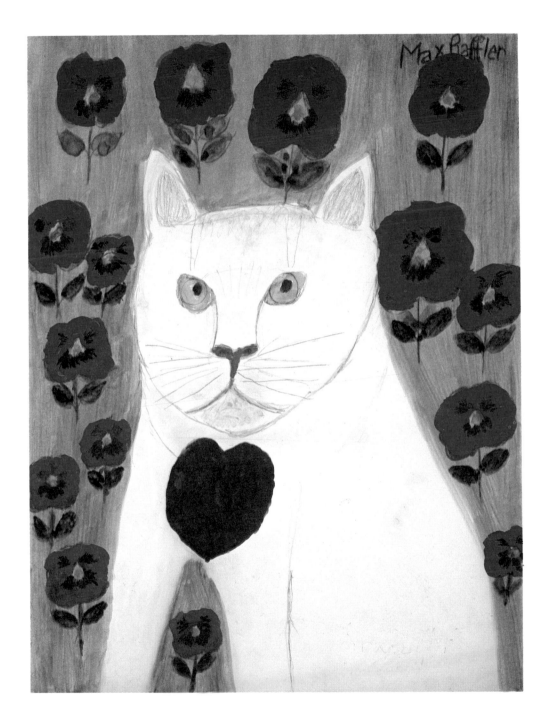

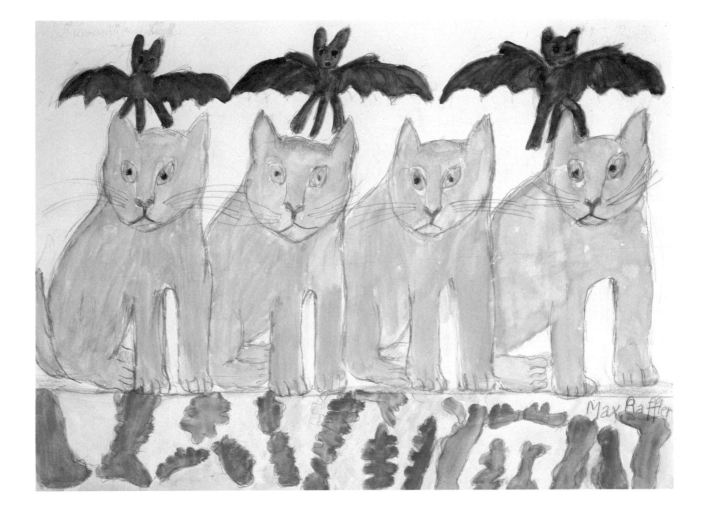

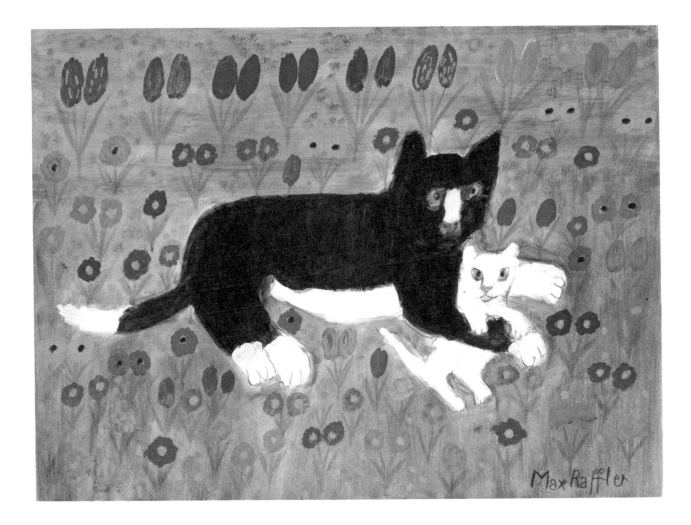

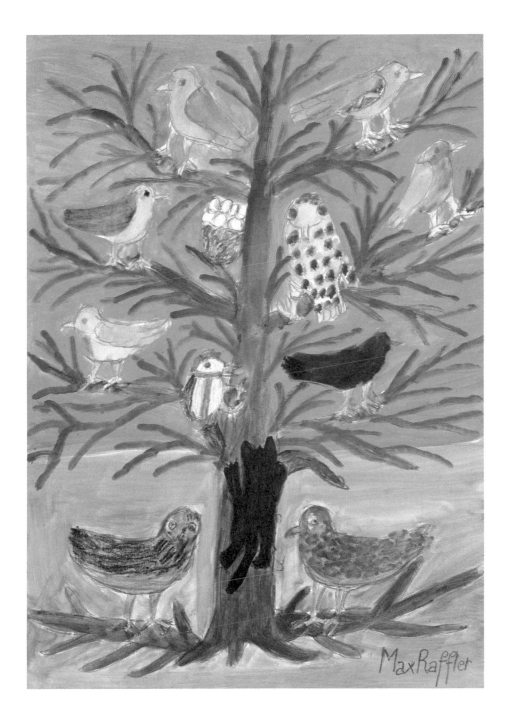

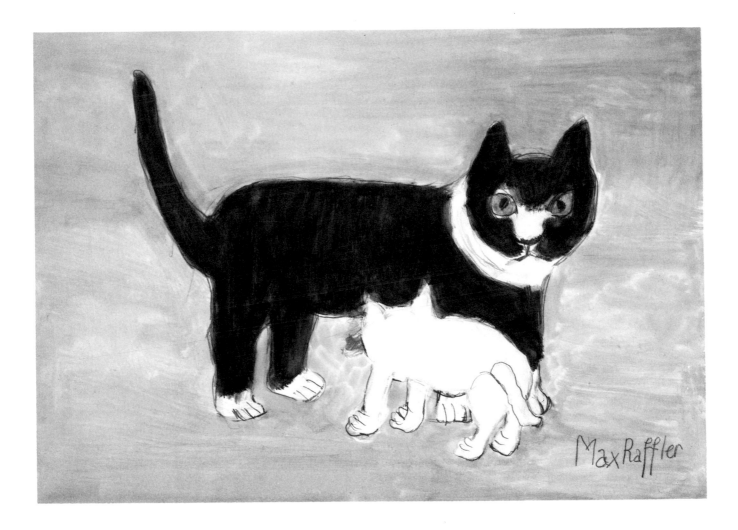

Max Raffler

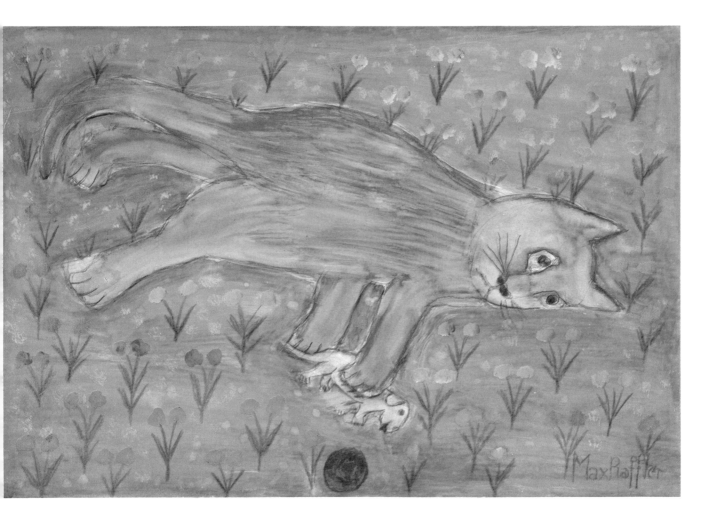

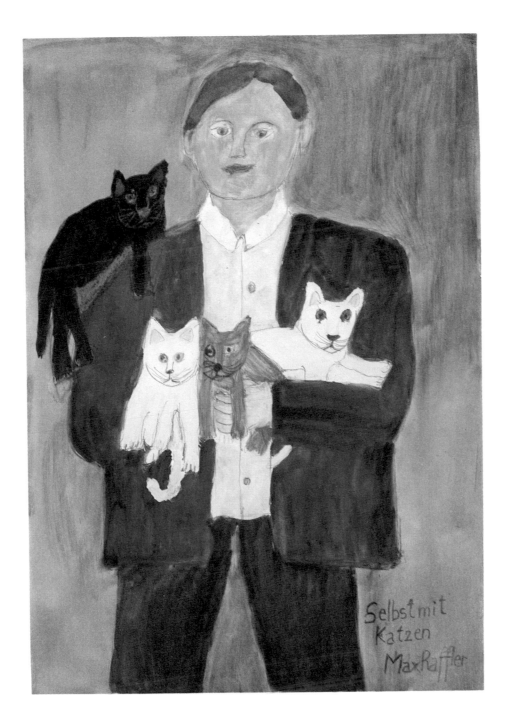

Selbst mit
Katzen
Max Raffler

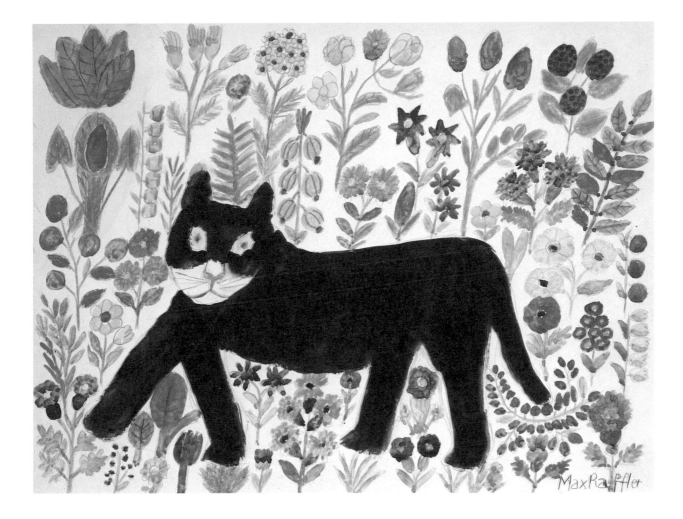

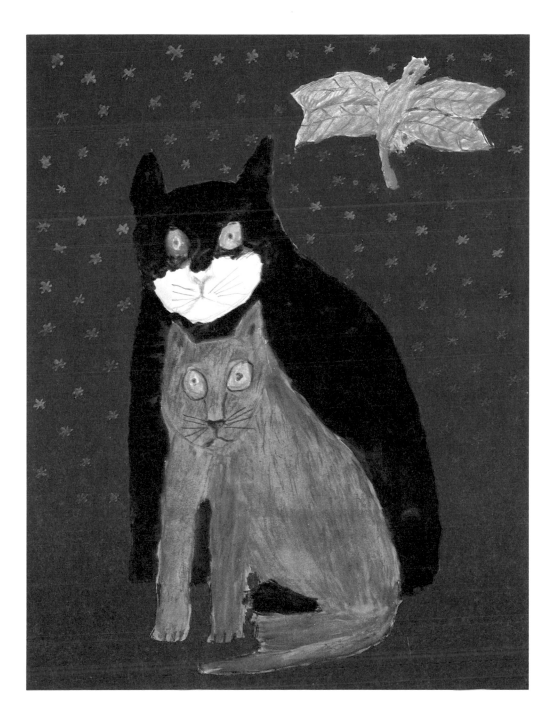

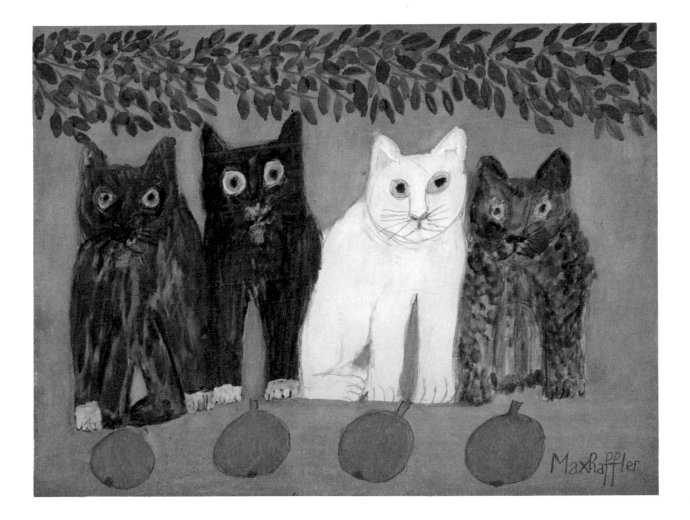

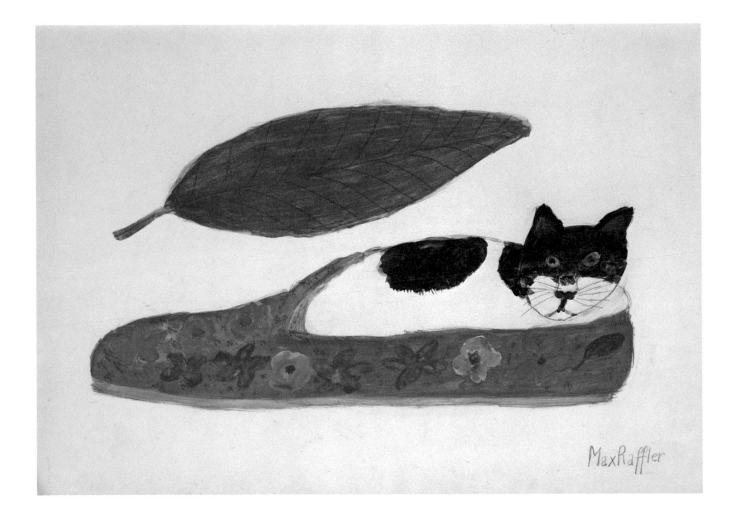

MaxRaffler

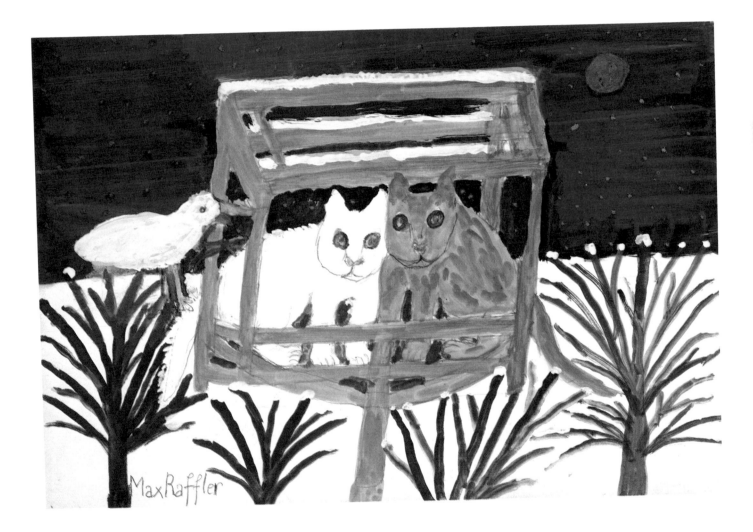

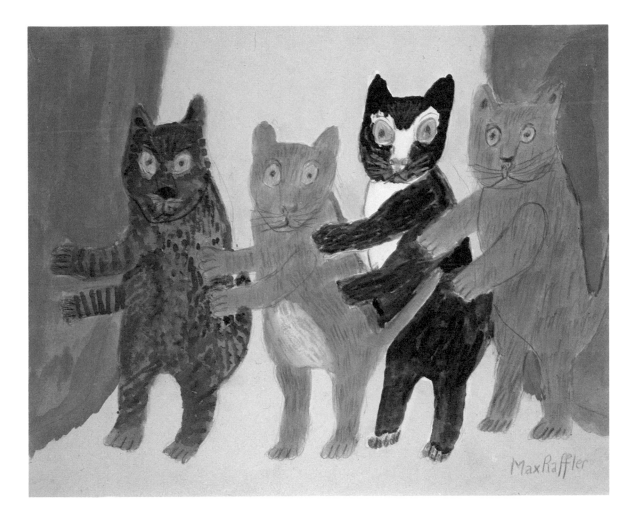

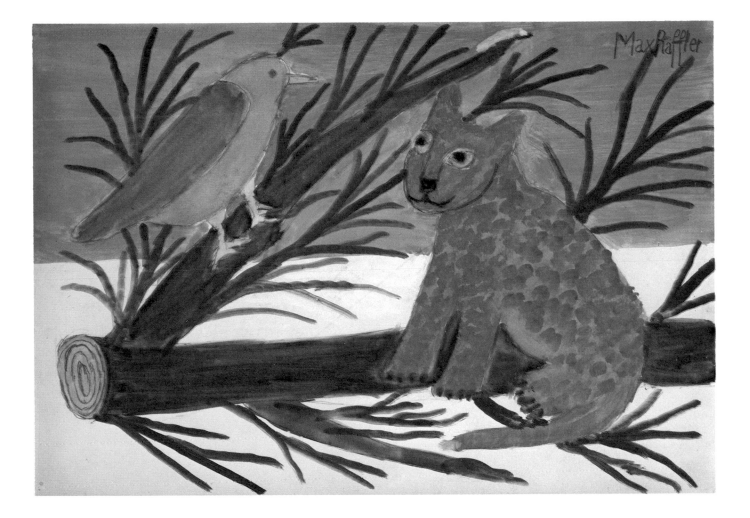

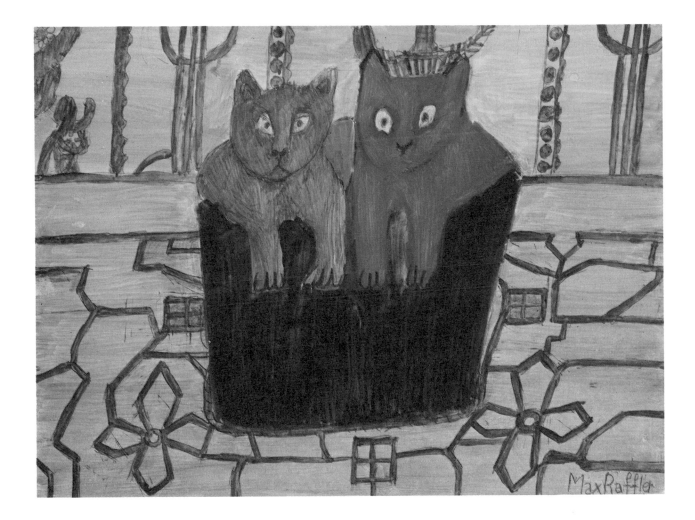

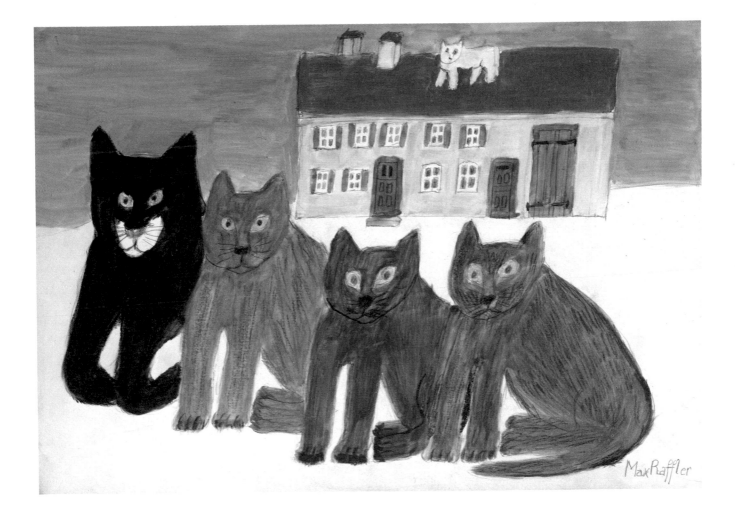

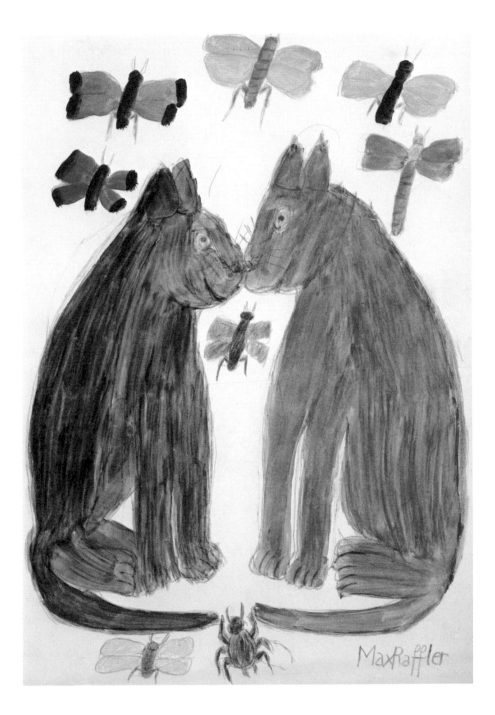

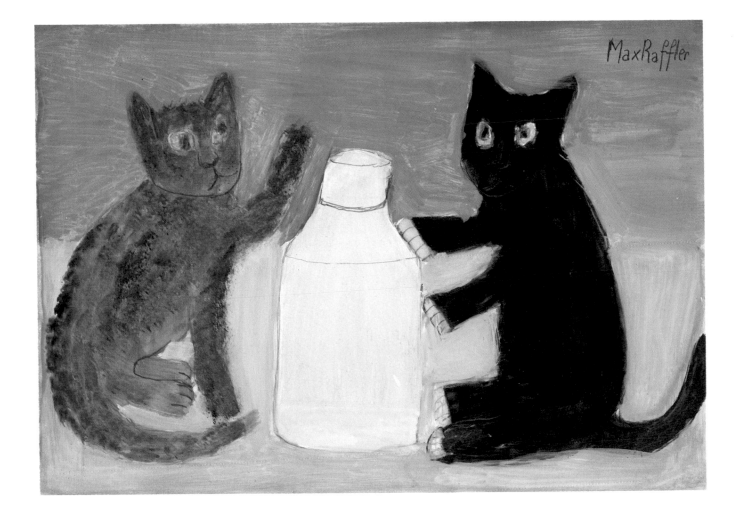

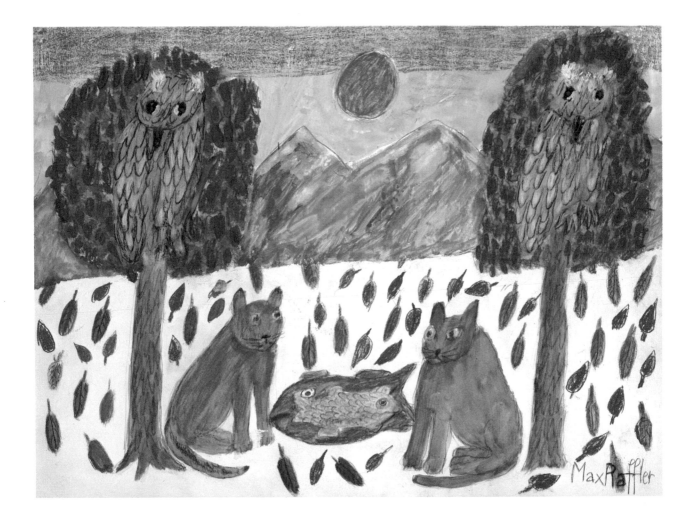

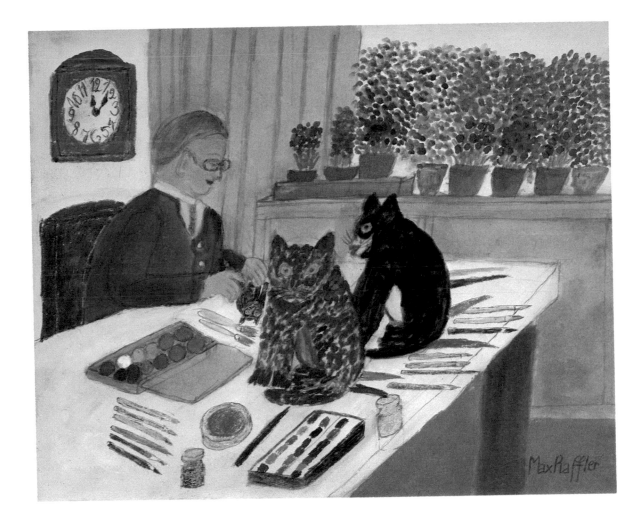

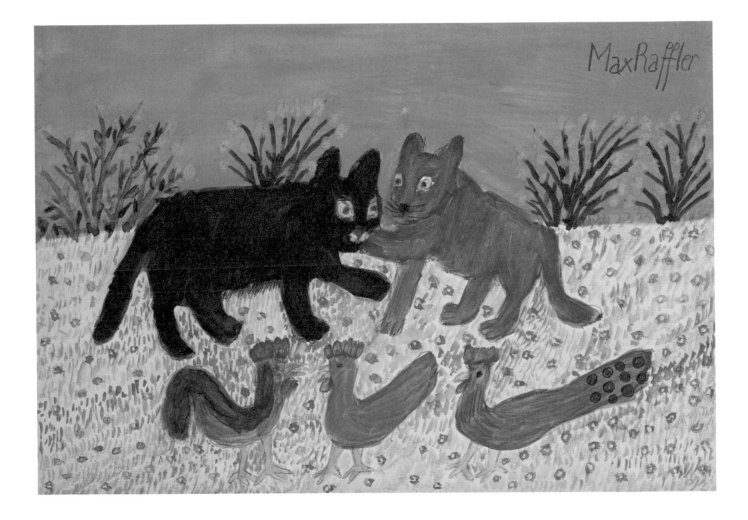

About the Author

MAX RAFFLER, one of six children born to a farmer descended from mayors and councilmen, began to paint at a very early age. He was a Sunday painter in the truest sense of the word: he would compose his pictures between working in the stables and attending church at noon on Sundays. In his younger days Raffler had very little time for art because, after his father's death, he had to oversee his family's estate in upper Bavaria.

Nevertheless, over the years he produced more than a thousand paintings and drawings, which brought him fame when he was in his sixties. Along with more than three thousand other participants from forty countries, he entered a competition for Sunday painters in Amsterdam, and the jury, which included the renowned artist Oskar Kokoschka, awarded him second prize. Raffler's paintings have been exhibited in Hamburg, Frankfurt, Munich, Amsterdam and Vienna, among other places; they are on display in the Bavarian National Museum and in many other major European galleries.

Cats appear time and again in Raffler's art. No other painter in the twentieth century has so tirelessly dedicated himself to cats. Raffler's cat paintings, brought together here for the first time, portray a unique, bizarre world where man and the other animals are, as it were, beside the point.

The publication of *Raffler's Cats* celebrates the occasion of Max Raffler's eightieth birthday on October 2, 1982.